VAN GOGH

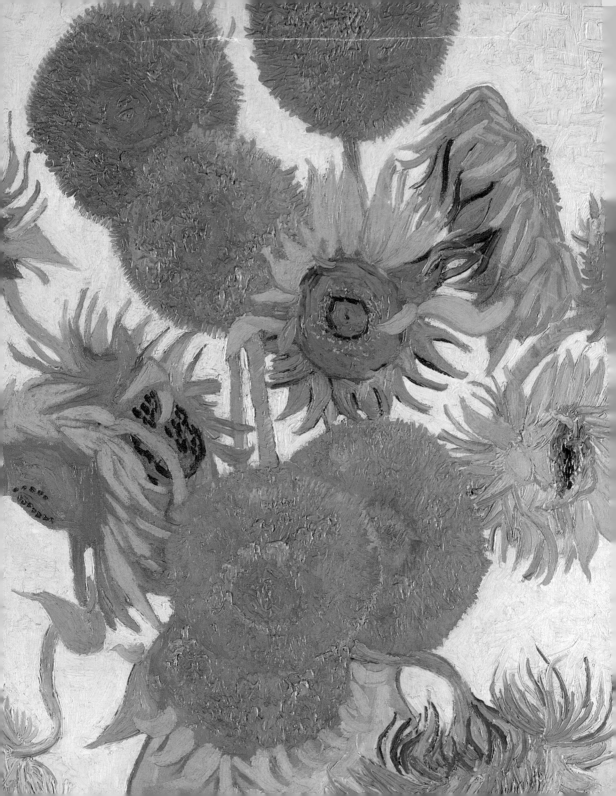

VAN GOGH

Hattie Spires

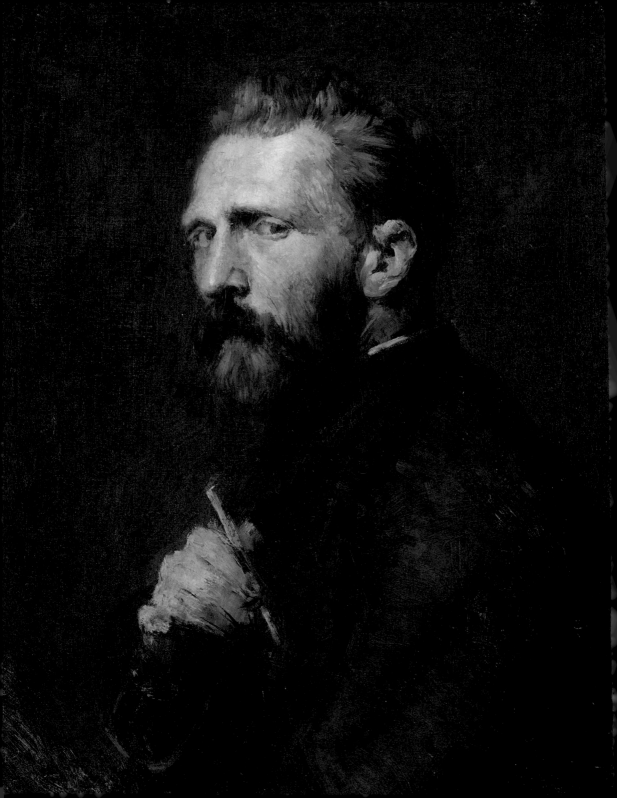

The paintings of Vincent van Gogh are among the most widely recognised, reproduced and influential in the history of Western art. Few artists have been scrutinised in such a wide variety of media, from biographies and films to pop songs. Just about every mid-range hotel will have a faded Van Gogh image somewhere on its walls and he once even featured in an episode of the British sci-fi drama *Doctor Who*. Famous for his pioneering use of colour, innovative brushwork and distortions of form for expressive effect, Van Gogh was among the first painters to be described as 'post-impressionist'.

By the time Van Gogh died in 1890, aged just thirty-seven, he had produced over 2,100 artworks, 860 of them oil paintings. He sold virtually no works during his ten-year career as an artist. He was largely self-taught, was not represented by a gallery, and was just beginning to receive attention from other artists and to have his work displayed in exhibitions when his life ended.

Much is known about Van Gogh's life and work through his letters. He had an extraordinary facility for expressing his thoughts on paper. Most of the 820 surviving letters were addressed to his younger brother Theo, whose unfailing emotional and financial support enabled Vincent to devote his life to painting.

Early life

Vincent Willem van Gogh was born 30 March 1853 into an upper-middle-class family in Groot-Zundert, a small Dutch village near the Belgian border. His father, Theodorus, a pastor of the Dutch Reformed Church, was 'warmly loved and respected'[1] and idolised by his eldest son, Vincent, whilst Anna Cornelius Carbentus was reputed to be a strong but sympathetic mother to her five children (fig.41).

Vincent was a strong-willed child with a love of flowers and animals. He showed no particular aptitude for drawing but, at sixteen, he was sent to work at the art gallery Goupil & Co in The Hague. He was

1. John Peter Russell
Vincent Van Gogh 1886
Oil paint on canvas
60.1 × 45.6
Van Gogh Museum,
Amsterdam (Vincent
van Gogh Foundation)

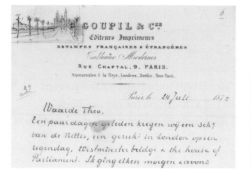
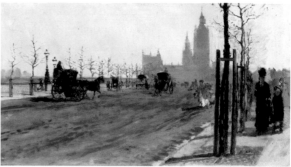

following in the footsteps of three of his uncles who had been art dealers. His uncle Vincent ('Uncle Cent') had been a successful partner at Goupil, and had arranged for his nephew to join the firm.

London

In June 1873 Van Gogh was promoted to the London branch of Goupil & Co, based at 17 Southampton Street off the Strand. He spent nearly two years in the city, the first of which he considered one of the happiest of his life.

London at that time was the largest and most technologically advanced city in the world, boasting a population of three million and the first underground railway. But despite the British capital's technological achievements, it was also full of poverty and slums. This disparity led Van Gogh to become interested in politics, and he became a radical.

The young Dutchman, although now earning a considerable salary, experienced bouts of homesickness, comforting himself by smoking a pipe. Nevertheless he found time to visit galleries and took long walks to Brighton and Box Hill. He devoured British culture and literature, reading Bunyan and Eliot, even re-reading Dickens's *Christmas Stories* every year.[2] Van Gogh was fluent in four languages. One artist friend, Hartrick, later reminisced that 'He had an extraordinary way of pouring out sentences, if he got started, in Dutch, English and French, then glancing back at you over his shoulder, and hissing through his teeth.'[3] Though not immediately a fan of English art, he listed the painters and works he did admire, including John Everett Millais's *Ophelia*, George Henry Boughton's *Pilgrims Going to Church*

2. Letter 039 to Theo van Gogh. Paris 1975 (detail)
21.3 × 27.2
Van Gogh Museum, Amsterdam (Vincent van Gogh Foundation)

3. Giuseppe De Nittis *Victoria Embankment, Westminster Bridge* 1875
Oil paint on canvas
18.4 × 31.7
Private Collection

and John Constable's landscapes. At the National Gallery he saw the newly acquired *Avenue at Middelharnis* by Meindert Hobbema (fig.5), with its tree-lined Dutch road. This was a motif that would recur throughout Van Gogh's artistic career (figs.13, 22, 23, 24).

While lodging in Stockwell, Van Gogh experienced the pain of unrequited love having declared his affections for his landlady's daughter, only to be rebuffed. His letters home in the wake of this rejection are depressed and increasingly religious.

Growing introspection and religious fervour

Hoping a change of scene would help his nephew, Uncle Cent engineered a temporary move to the Paris branch of Goupil, away from the London fog that Vincent's mother feared had got him down.[4]

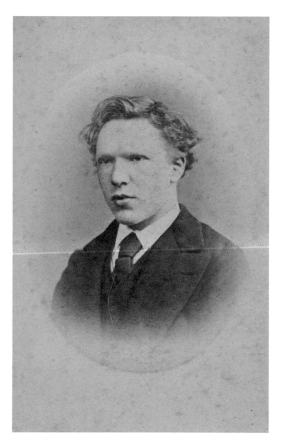

4. J.M.W. de Louw
Vincent van Gogh at age 19
1873
Van Gogh Museum,
Amsterdam (Vincent
van Gogh Foundation)

In July 1875, a painting by the Italian impressionist Giuseppe De Nittis was consigned to the gallery. It depicted the newly built Embankment in London (fig.3), from which Vincent used to make drawings on his way home from work. Vincent sketched the painting in a letter home to Theo (fig.2): 'I crossed Westminster Bridge every morning and evening, and I know what it looks like when the sun's setting behind Westminster Abbey and the Houses of Parliament… When I saw this painting I felt how much I love London.'[5]

Unhappy in Paris, Vincent no longer wished to work as an art dealer and in January 1876, he was dismissed from Goupil for being too honest with his clients, passing judgement on their tastes and voicing his strong opinions on art. Disillusioned and not knowing which path to follow next, Vincent entered a period of long and difficult experiments in the hunt for a profession. Ignoring Theo's suggestions that he become an artist, he returned to England in April 1876 where he worked as an unpaid teacher at a boys' boarding school in Ramsgate. When the school relocated to Isleworth, he began an intense spiritual search, giving his first sermon based on Boughton's *Godspeed!*. With no prospect of paid employment as a teacher, his family secured Vincent a job as a clerk at a bookstore in Dordrecht.

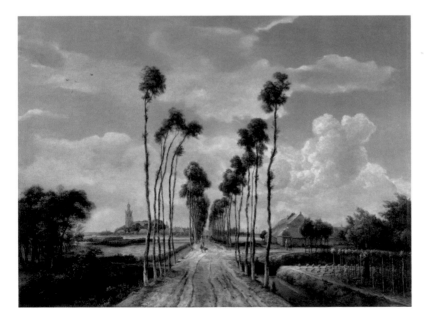

5. Meindert Hobbema
The Avenue at Middelharnis 1689
Oil paint on canvas
103.5 × 141
The National Gallery, London

There he slept little and ate even less. He spent his free time reading the Bible and hammering drawings and prints into 'the good wallpaper' in his room, much to his landlord's irritation.[6] After a miserable, unproductive time there he determined to follow in his father's footsteps and train as a preacher. He moved in with his Uncle Jan in Amsterdam and commenced theology studies, which involved learning Latin and Greek. Despite much exertion he failed his exams.

Clinging on to religion through his despair, he devoted himself to becoming an evangelist. He set off for Pâturages, a village in the Borinage coal-mining region in Belgium. In January 1879, he secured a temporary preaching position, caring for the injured and sick and delivering sermons at meetings. This was a time of humility that led him to give away his bed and sleep on the floor of a miner's hut in an effort to follow the teachings of the Bible.

In August 1879 Vincent experienced his first major altercation with his family after a visit from Theo, who had alerted his relatives to Vincent's wretched lifestyle. Meanwhile, the Belgian evangelism committee concluded that Vincent was setting a poor example to others and released him from his duties.

Van Gogh had reached his nadir. Jobless and friendless, his religious fervour dimmed. The hard grind of workers in the Borinage, however, stirred the artistic spirit in him and he took up his pencil in place of the Bible. His letters lost their religious zeal and he described a period of metamorphosis: 'You will ask, What is your definite aim? That aim becomes more definite, will stand out slowly and surely, as the rough draft becomes a sketch, the sketch becomes a picture – little by little … till it gets fixed.'[7] His aim finally became fixed in 1880, when Van Gogh was twenty-seven. From then on he devoted himself to being an artist.

Home again

'Homesick for the land of pictures',[8] Van Gogh headed for the nearest city, Brussels, hoping to come into contact with artists. He made the acquaintance, via Theo, of the painter Anthon van Rappard and the two eventually hit it off. Vincent shared a studio space with him and dabbled in drawing lessons, preferring this to the formal training of the Academy.

Money was tight, and he returned home to the vicarage in Etten to live with his parents for eight months. During the summer of 1881 Vincent once again alienated his family by making unwelcome proposals to a cousin who was visiting from Amsterdam. The episode resulted in a violent fight with his father, and Vincent's swift departure for The Hague.

The Hague, 1882

Theo arranged for Vincent to meet Anton Mauve, a leading realist painter of The Hague School, who was related to the brothers by marriage. Mauve encouraged Vincent to pursue his artistic work. He spent three months at Mauve's studio where he first experimented with paint.

After a time their relationship fractured, precipitated by Van Gogh befriending a woman named Clasina Maria Hoornik, or 'Sien', whom he met at a soup kitchen. Sien worked as a prostitute and had a young child and was pregnant when Vincent met her. He secretly set up home with her, on Theo's expenses, and she modelled for him (fig.6). He made a number of pictures of their domestic life together but the relationship was the last straw for the family, and all but Theo withdrew their support for Vincent. "What is more cultured, more sensitive, more manly: to foresake a woman or to take on a forsaken one?"[9] he wrote in his defence. By the summer of 1883, with the household in disarray, it was clear that Vincent could not support a family and pursue his artistic career. After a sorrowful departure, he left Sien and her children.

Nuenen and Antwerp, 1885

With his resources dwindling, Vincent returned to the family home, which had by now moved to Nuenen, a village near Eindhoven. Despite their previous ruptures, Vincent was once again welcomed like the prodigal son. He took over the mangling room at the vicarage, now refurbished into a studio, and his parents allowed him his eccentric attire – Vincent himself described his appearance as 'shocking'[10] at this time, wearing a battered top hat (a hangover from his days in London) and worn clothes – though it lost them the friendship of their neighbours. His paintings from that time captured the gloomy homes of the weavers and the toil of the peasants (fig.38)

6. *Sorrow* November 1882
Graphite, pen and
ink on paper
44.5 × 27
The New Art Gallery
Walsall

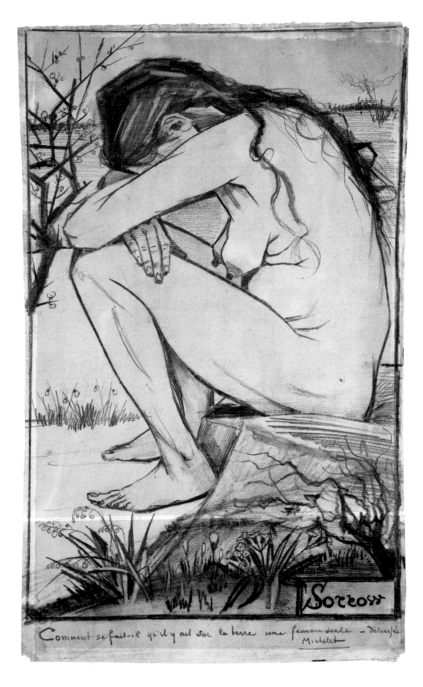

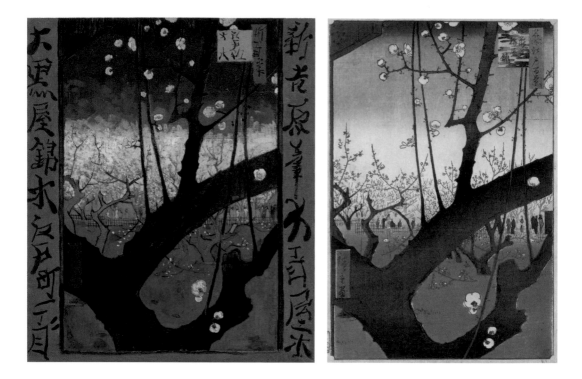

in a palette that reflected the fields that they worked. He spoke little, mixed with very few people and immersed himself in his art.

Feeling his work was of a saleable standard, he sent *The Potato Eaters* 1885 (fig.26) to his brother with the hope of finding a buyer. The painting met with criticism for its grotesque characters and murky palette. It was a harsh lesson for him. And when Vincent's father died, the new priest did not look on Vincent's occupation of the studio favourably. It was time to move on again.

He left for Antwerp in autumn 1885. It was here that he started to take an interest in Japanese prints, which he admired for their heightened colour and bold composition. He went on to make copies of prints by the master printmakers Hiroshige (figs.7, 8) and Hokusai among others.

Vincent enrolled at the Royal Academy of Fine Arts in Antwerp but, with no aptitude for study, found the lessons unbearable. During his three-month stay he worked feverishly and exhausted himself, spending on models money that ought to have been used for food.

7. *Flowering Plum Orchard (after Hiroshige)* 1887
Oil paint on canvas
55.6 × 46.8
Van Gogh Museum, Amsterdam (Vincent van Gogh Foundation)

8. Utagawa Hiroshige
The Residence with Plum Trees at Kameido, from the series *One Hundred Views of Famous Places in Edo*
1857
Woodcut print
37 × 25.4
Van Gogh Museum, Amsterdam (Vincent van Gogh Foundation)

Paris, 1886–8

Vincent arrived in Paris on 28 February 1886 and stayed for two years. This period saw a dramatic shift in his palette and subject matter from social to aesthetic concerns. Paris was the centre of the avant-garde at this time and Theo was working at the heart of it, by now managing a gallery in Montmartre that he had turned into a centre for impressionism.

Vincent moved into Theo's small apartment on the rue Laval. Finally taking the advice of friends that he should undertake some formal training, he enrolled at the studio of the academic painter Fernand Cormon where he took drawing lessons working from live models and plaster casts (fig.27). Vincent again found the didactic nature of the work suffocating, and after only three months he abandoned his studies.

He did, however, make significant connections with other artists during his time there, including Louis Anquetin, Émile Bernard and Henri de Toulouse-Lautrec. Vincent also befriended the Scottish art dealer Alexander Reid (fig.30), who would later exhibit his work in London. In fact, in Paris, he finally found a band of brothers with whom to talk about art and exchange ideas.

9. Lucien Pissarro
Van Gogh in conversation
1888
Chalk on paper
17.8 × 22.5
Ashmolean Museum, Oxford. Pissarro Family Gift, 1952

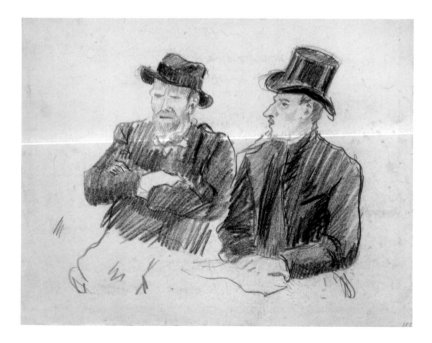

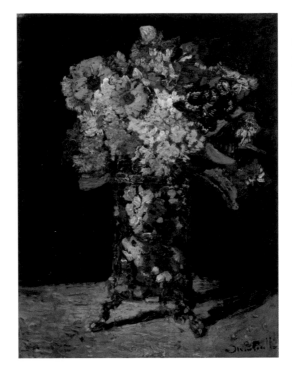

10. Adolphe Monticelli
Vase with Flowers c.1875
Oil paint on canvas
51 × 39
Van Gogh Museum,
Amsterdam (Vincent
van Gogh Foundation)

Theo visited him at this time, and wrote to their family how well things were going for Vincent: 'many people here like him ... he has friends who send him every week a lot of beautiful flowers which he uses for still life.'[11] These still-lifes from the summer of 1886 saw his palette brighten. The series was partly driven by a lack of funds to pay for models, but it was also inspired by the Provençal painter Adolphe Monticelli whom Vincent greatly admired. Taking Monticelli's trademark flowers set against a sombre background (fig.10), Vincent placed them on his own luminous backgrounds (fig.11). He hoped the pictures would be saleable and exhibited them in one of his favourite haunts, the Café du Tambourin, which was run by his then girlfriend Agostina Segatori (fig.35). Vincent urged his brother to promote his work but it was not to Theo's clients' conservative tastes.

An emerging group of artists, known as the impressionists, were beginning to cause a stir at that time in Paris. Van Gogh almost certainly saw their work in the last impressionist group exhibition of 1886 but thought little of it.[12] Certain pictures attracted his attention,

however, such as Degas's nude figures and Monet's landscapes. The individual brushstrokes and lighter palette in Van Gogh's early Parisian works (see fig.29) reveal these artists' influence.

His attention turned from flowers to other subjects for his still-lifes such as old pairs of boots (fig.28). A fellow student at Cormon's studio recalled Vincent buying a pair of boots at a flea market and taking them for a walk in the rain. 'Spotted with mud they had become more interesting' and he committed them to canvas.[13]

In early 1887, Vincent started to paint with his friend Émile Bernard in Asnières-sur-Seine, a northwest suburb of the city. There he encountered the pointillist Paul Signac, and incorporated elements of his style in a series of landscapes that further shortened his

11. *Sunflowers* 1888
Oil paint on canvas
92 × 73
Neue Pinakothek, Munich

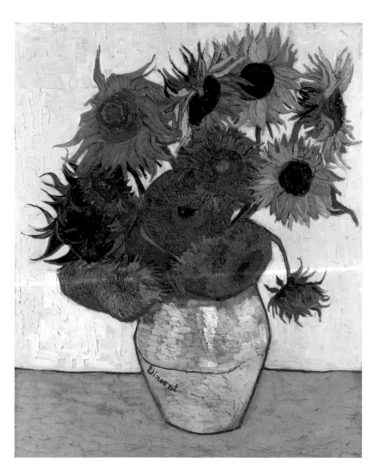

brushstrokes and lightened his palette. He and Theo also visited the studio of the neo-impressionist painter Georges Seurat.

In the winter of 1887–8, Vincent returned to painting portraits, including one of himself before an easel and another of the colour merchant Julien 'Père' Tanguy (fig.31), who supported young artists by displaying their works in his shop window on the rue Clauzel or accepting their paintings in exchange for artist materials.

Fringe artists were always looking for opportunities to display their work in restaurants, cafés and other informal spaces[14] and Vincent proved to be an adept exhibition-maker, organising *Impressionists of the Petit Boulevard* in November 1887 at the Grand Bouillon-Restaurant du Chalet, with works by Bernard, Antequin, Seurat and Toulouse-Lautrec as well as his own.

12. *The Yellow House* (The Street) September 1888
Oil paint on canvas
72 × 91.5
Van Gogh Museum, Amsterdam (Vincent van Gogh Foundation)

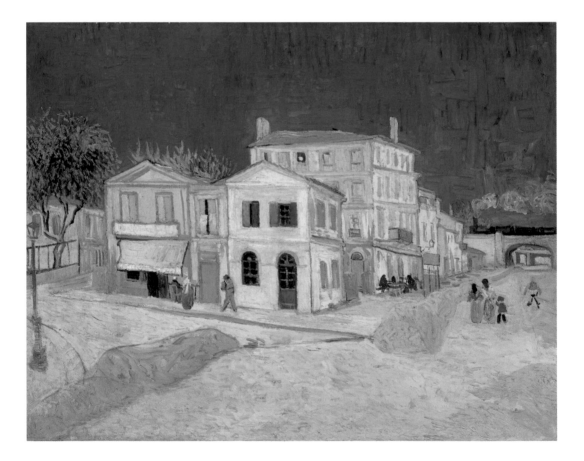

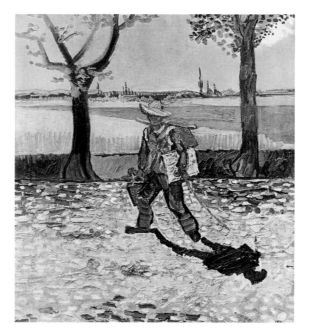

13. *The Painter on the Road to Tarascon* July 1888 reproduced as the frontispiece in Wilhelm Udhe and Ludwig Goldscheider, *Vincent Van Gogh* 1936
Original destroyed by fire in the Second World War, formerly in the collection of the Kaiser-Friedrich Museum, Magdeburg

The cold Parisian climate and city bustle eventually got the better of Vincent and he set off for the south of France. Before vacating, he arranged his room at Theo's apartment to look like his current studio and he left *Self-Portrait as a Painter* 1887–8 with Theo as a parting gift.[15] It was snowing when Vincent arrived in Arles on 20 February 1888.[16] He had intended to travel to Marseille with just a quick visit to the medieval town, but instead spent fifteen months there. He produced three paintings per week during this period and his palette reflected the blazing Provençal sun as he further heightened his use of colour.

The Yellow House, Arles

Two months into his stay in Arles he rented 2 Place Lamartine, and for the first time he had a large space of his own. He found it in a state of disrepair but, after some work, freshening the exterior paintwork, and requesting extra funds from Theo for furnishings, his 'little yellow house' became both his studio and living space. Vincent's domestic contentment is captured in *The Bedroom* 1888 (fig.37).

Vincent loved painting outside in the countryside of Provence and first described himself as a landscape painter there. *The Painter on the*

Road to Tarascon 1888 (fig.13) is a self-portrait of the Dutchman setting off for a day's work *en plein air*. He painted in the strong winds of the mistral, pegging his easel into the ground as he felt it was too beautiful not to work.

Painting night without black
Gaslight was relatively new in the 1880s. Interested in the effect of artificial light on colour, Van Gogh set up his easel in one of the many 'night cafés' in Arles where people stayed who could not afford lodgings. He tried to convey the late-night mood of a 'place where you can ruin yourself, go mad, commit crimes … in an ambience of a hellish furnace in sulphur yellow'[17], with customers resting their heads on their hands while prostitutes solicited clients nearby. He painted *The Night Café* (fig.40), *Café Terrace at Night* (fig.47) and *Starry Night Over the Rhône* between September and October 1888, rendering each night-time scene in luminous colour.

The Painter of Sunflowers
In the Yellow House Vincent had found a flexible space where he could not only paint but accommodate friends. He wanted to set up an artists' colony, a 'studio of the south' where like-minded painters could work together. Vincent had met Paul Gauguin briefly in Paris in December 1887 and he implored the artist to join him in Arles to set up their colony. After some resistance and partly through an offer of financial assistance by Theo, Gauguin agreed. Vincent set about decorating Gauguin's room with paintings of sunflowers. The excitement of the impending visit is tangible in a letter to Theo, in which Vincent writes: 'I'm painting with the gusto of a Marseillais eating bouillabaisse'.[18]

Van Gogh produced four sunflower paintings in one week (fig.11). Taking what he had learnt from Monticelli in Paris and making the colours sing, the fourth work in the *Sunflowers* series (fig.42) is considered by many to be the artist's masterpiece. It adorned the bedroom wall of Gauguin as a welcome to his new guest.

Van Gogh and Gauguin
Gauguin arrived at the end of October 1888, and was struck by Vincent's living and working conditions. Later, Gauguin would write

about the chaos he found: 'his box of colours was barely big enough to contain all those squeezed tubes, which were never capped up, and despite all this disorder, all this mess, everything glowed on the canvas.'[19] He took over the household's finances and did the cooking, leaving Vincent with the food shopping. During their first week together Van Gogh painted *Trunk of an Old Yew Tree* (fig.46) and *Les Alyscamps.* The two artists debated art late into the night, set up their easels outside together, visited the local brothel regularly and generally spurred each other on. Gauguin encouraged Van Gogh to paint from memory, which he did in *Arena in Arles* 1888 after his visit to the amphitheatre.[20]

He painted two 'portraits' of empty chairs during Gauguin's stay. *Van Gogh's Chair* (fig.43), with its pipe and tobacco, and *Gauguin's*

14. Paul Gauguin
Vincent van Gogh Painting Sunflowers, Arles 1888
Oil paint on canvas
73 × 91
Van Gogh Museum, Amsterdam (Vincent van Gogh Foundation)

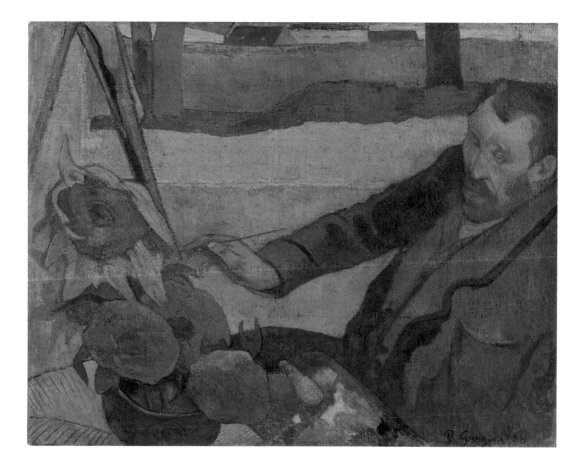

Chair (fig.44), on which sits a burning candle and two novels, are suggestive of their more contented times together.

The pair also painted Augustine Roulin, the wife of Joseph Roulin, the local postman who was Van Gogh's drinking partner and closest friend during his time in Arles (fig.49). Vincent's portrait of Augustine, *La Berceuse* (fig.50), was intended to be hung in a sailor's cabin to calm those at sea: the little rope that Madame Roulin holds to pull the cradle, he imagined, would rock the sailor's pitching boat. He also painted Paul-Eugène Milliet, a second lieutenant in a Zouave regiment of the French army (fig.39), and his Belgian artist friend, Eugène Boch.

In December 1888, Gauguin captured Vincent in *Vincent van Gogh Painting Sunflowers* (fig.14). Theo thought it the most accurate portrayal of his brother 'in terms of capturing his inner being'.[21]

Gauguin's departure

The two artists had a tempestuous relationship, however; their tastes and methods of working varied greatly. During a drunken altercation Van Gogh flung his absinthe glass at Gauguin's head. According to Gauguin, 'I avoided the blow and, wrestling him at the chest, I left the cafe.'[22]

A period of relative calm ensued but was interrupted on 23 December 1888 by news that Theo had become engaged to Johanna Bonger (fig.20). Vincent already feared his brother's emotional and financial support might be threatened, and that evening he allegedly threatened Gauguin with an open razor before cutting off his own left ear. He wrapped it in paper and took it to a favoured maid working at the local brothel who fainted upon receiving it.

Vincent spent two weeks in hospital in Arles. Gauguin left for good and Roulin was about to be transferred to Marseille, leaving Van Gogh alone. On his return home he produced *Self-Portrait with Bandaged Ear and Pipe* 1889 (fig.54), which starkly portrays his injury, perhaps in a bid to help him come to terms with it.

Despite the upset, this was the start of an astonishingly productive period in which Vincent completed the remaining sunflowers pictures. By early February 1889 he was unwell again and, suffering paranoid hallucinations, he returned to hospital. After a week he ventured out on day release but, without any allies to smooth his return, locals started to voice concerns about their volatile neighbour.

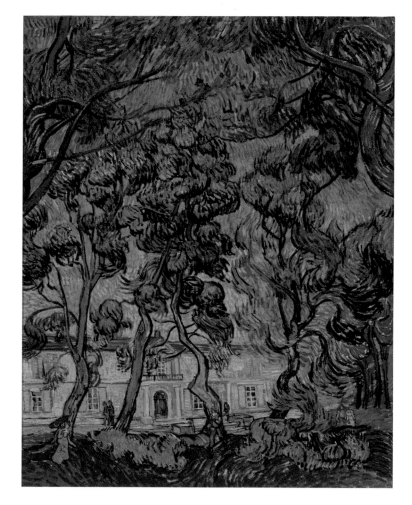

15. *Hospital at Saint-Rémy*
October 1889
Oil paint on canvas
92.2 × 73.4
Gift of the Armand
Hammer Foundation.
Hammer Museum,
Los Angeles.

They petitioned for Vincent to be investigated, declaring that he was 'not in full possession of his mental facilities ... he over-indulges in drink, after which he is in a state of over-excitement such as he no longer knows what he is doing'.[23] Vincent was deeply upset by their allegations. He was once again admitted to hospital and the police locked up the Yellow House.

'The Saint-Paul Year', May 1889–90
On 8 May 1889, after months of hospital treatment in Arles, Vincent allowed himself to be committed to the Saint-Paul de Mausole

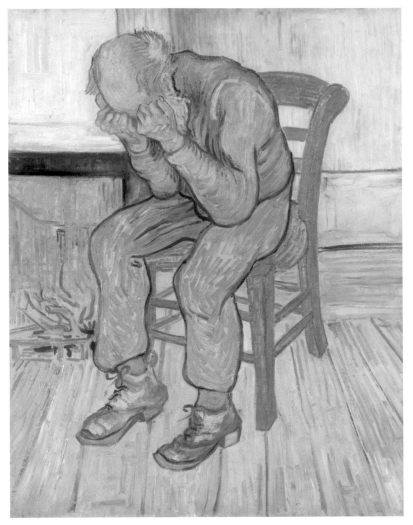

16. *Sorrowing old man ('At Eternity's Gate')* May 1910
Oil paint on canvas
81.8 × 65.5
Kröller-Müller Museum, Otterlo

psychiatric institution near Saint-Rémy-de-Provence (fig.15). During his stay Vincent made numerous paintings and drawings, first in the asylum and its gardens and later beyond, among the olive gardens and cypresses in the Alpilles mountains. Saint-Paul served as the setting for many of his most famous works.

Theo wrote a letter formally requesting his brother be given half a litre of wine with his meals and allowed 'the freedom to paint outside the institution'.[24] On his first full day at Saint-Paul, within the

confines of the asylum's walled garden, Vincent painted *Irises* (fig.52). The wall features in many of his works from this period, along with the Alpilles that rise above it, as seen in *Landscape from Saint-Rémy*. His bedroom with its little barred windows, overlooked a wheatfield and the sunrise, and he was allocated a second room for his studio.[25] He returned to the wheatfield and its magnificent backdrop time and again during his stay to study the changing seasons. It was another highly productive period for him; just over 150 paintings survive from this time, and a further number have been lost. This equates to his painting approximately one picture every two days.

He occasionally ventured beyond the confines of Saint-Paul, sometimes walking twenty kilometres out into the landscape to paint. On several occasions he walked as far as Arles, visiting his old cleaning lady. Vincent produced a series of olive trees during this period (fig.53), capturing their gnarled, twisted trunks and ancient branches across the seasons. He gave the same treatment to the cypress trees, culminating in *A Wheatfield with Cypresses* (fig.48) with its swaying band of billowing, ripe wheat and animated sky.

Van Gogh described his episodes of ill mental health as 'crises'. He suffered four during his time at Saint-Paul, two of which involved him trying to poison himself with his paints. His materials were confiscated and he petitioned Theo to have them returned to him. 'I'm ploughing on like a man possessed, more than ever I have a pent-up fury for work, and I think this will contribute to curing me.'[26]

We know that Vincent experienced aural and visual hallucinations, but, despite conferences held on the subject, no-one is in exact agreement about his diagnosis. Misuse of absinthe, lead poisoning and bipolar disorder have all been suggested. His own doctors believed it was epilepsy.

When he was too sick to leave his room, Vincent painted from his collection of black-and-white prints. *Sorrowing Old Man ('At Eternity's Gate')* 1890 (fig.16) is a copy of one of his own drawings from 1882. It depicts a man sitting on a chair beside a fire, head in his hands with clenched fists. This may be a self-portrait since his doctor described Vincent during his periods of sickness as sitting 'with his head in his hands, and if someone speaks to him, it is as though it hurts him, and he gestures for them to leave him alone'.[27]

Auvers-sur-Oise, 1890

Vincent spent the final months of his life in Auvers-sur-Oise. The village, thirty kilometres north of Paris, was the home of Dr Gachet, a homeopathic doctor and amateur artist who associated with many impressionists. There Vincent could live independently, with Dr Gachet keeping a watchful eye and Theo, Johanna and Vincent's young nephew just over an hour away by train in Paris. Vincent lodged at the Auberge Ravoux, regularly visiting the Gachets who became friends and the subject of several portraits. *Dr Paul Gachet* 1890 (fig.59) emphasises the physician's state of mind – which, Vincent suggested, was worse than his own – above his professional qualities. In an extraordinary burst of energy, Vincent made one painting per day during this period, many of them showcasing the techniques that he had adopted. The influence of Japanese woodblock prints is still evident in *The Church in Auvers-sur-Oise* (fig.58), as are the striated brushstrokes of the impressionists.

Wheatfield with Crows (fig.60) has been posthumously associated with the artist's death. His letters describe trying to paint 'immense stretches of wheatfields under turbulent skies, and I made a point of trying to express sadness, extreme loneliness'.[28] Van Gogh shot himself on 27 July 1890, in the fields behind the château at Auvers. Stumbling back to his room, clutching his stomach, he died there, in Theo's arms, two days later. His coffin was adorned with yellow dahlias and sunflowers.

Recognition in his lifetime

It is often said that Van Gogh received no recognition in his lifetime and died penniless. While the second point is true, the first is an exaggeration. He often swapped paintings with other artists such as Émile Bernard and Paul Gauguin. A serious critique of his work by Albert Aurier was published in the journal *Mercure de France* in Paris in January 1890 and his work was exhibited in three significant shows while he was in the asylum in Saint-Rémy-de-Provence.

As for sales, Theo sold a painting to a gallery in London; Vincent sold one to the Parisian paint merchant Julien Tanguy; and Anna Boch, the sister of Vincent's friend Eugène Boch, bought *The Red Vineyard* 1888.

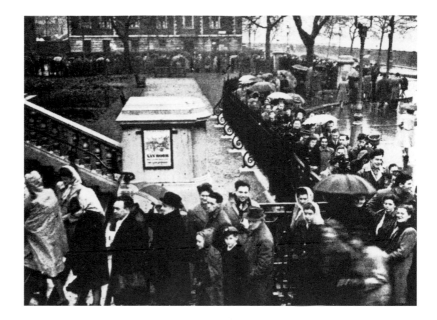

17. Photograph of the opening of the Tate Van Gogh exhibition, 9 December 1947. *Time*, 26 January 1948
Tate Public Records TG 92/62/1 (Transferred to Tate Exhibitions and displays, Tate Archive Photographic collection)

Legacy on British art

Gauguin would write about his time with Van Gogh in the Yellow House in 1903, fifteen years after they parted company. 'Unbeknown to the public, two men had accomplished there a colossal amount of work, useful to them both – perhaps to others.'[29] From our vantage point in the twenty-first century, there is no 'perhaps' about it. Vincent's reception evolved from radical innovator in painting in the early 1900s, to a 'tragic' artist who was exhibited with other 'tortured' artists such as Chaïm Soutine. During the Great War and Spanish Civil War, Van Gogh became an existentialist hero, and rhapsodic biographies quickly followed. His work was deemed 'degenerate' by the Nazis during the Second World War, and spirited away into underground bunkers. He re-emerged in peacetime in blockbuster touring exhibitions (fig.17) as a martyr figure and embodiment of personal and artistic freedom.

It took Johanna van Gogh-Bonger (the unsung hero in the story of Vincent van Gogh)[30] twenty-four years to publish the first volume of the artist's letters but they have since been read by countless artists. Artists not only adopted aspects of Van Gogh's technique but also aimed to live their lives in a similar style to him, going on sojourns to

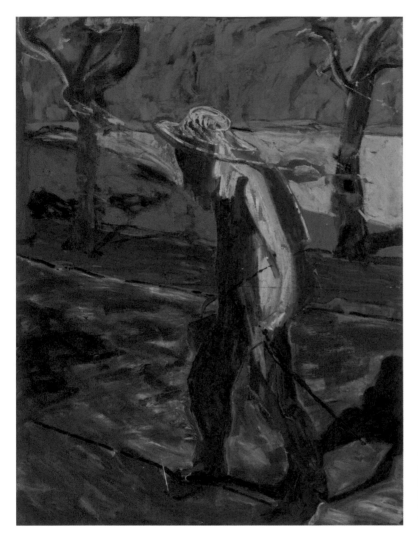

18. Francis Bacon
Study for Portrait of Van Gogh IV 1957
Oil paint on canvas
152.4 × 116.8
Tate

the south of France and painting directly from nature. The exhibition *Manet and the Post-Impressionists* at Grafton Galleries, London in 1910 was the first time that works by Van Gogh were exhibited in Great Britain. Works in the group exhibition, especially *Portrait of a Young Man with a Cornflower* 1890 and the *Postman Roulin* 1888 were a lightning rod for conservative ridicule (fig.19). For some young British artists, however, especially younger members of the Camden Town Group under the tutelage of Walter Sickert, such as Harold

Gilman, Charles Ginner and Spencer Gore, the show was a watershed moment.[31] These artists adopted Vincent's motifs and adapted them to their own work. Gilman's heightened use of colour, similar subject matter, such as in *Bridge at Arles (Pont de Langlois)* (fig.36), and use of dramatically cropped compositions are an elegy to the artist. Jacob Epstein painted Epping Forest in the style of Provence (fig.21), while Joan Eardley's portraits of street children in Glasgow echo Van Gogh's

19. H.M. Bateman 'Post Impressions of Post-Impressionist', *Bystander: An Illustrated Weekly, Devoted to Travel, Literature, Art, The Drama, Progress, Locomotion*, vol.28, Oct.–Dec. 1910

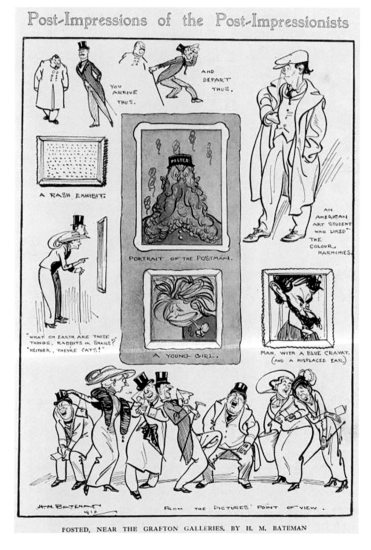

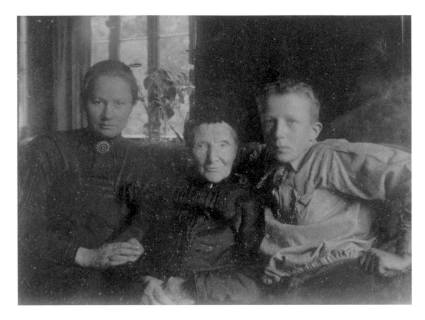

20. *Photograph of Jo van Gogh-Bonger with her son Vincent Willem and her mother-in-law Anna Cornelius* date unknown Van Gogh Museum, Amsterdam (Vincent van Gogh Foundation)

social concerns. Francis Bacon made a series (fig.18) based on the *Painter on The Road to Tarascon* (fig.13), partly catalysed by the release of the biopic *Lust for Life in London* in 1957.

His ability to strip out the clutter from traditional Victorian scenes, paring them down to a single motif – a chair, a bunch of sunflowers or a pair of boots – and somehow imbuing them with meaning, paved the way for generations of art students to come.

Van Gogh wanted to be an artist for the people and to disseminate his gift as widely as possible. To know that posters of his works hang on hotel walls across the globe would undoubtedly have pleased him.

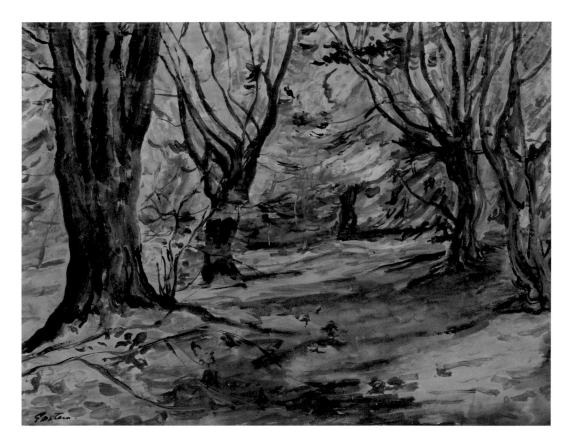

21. Jacob Epstein
Epping Forest c.1993
Watercolour and
gouache on paper
45.1 × 57.4
Tate

22. *Five Men and a Child
in the Snow* 1883
Chalk and watercolour
on envelope paper
13.8 × 10.5
Van Gogh Museum,
Amsterdam (Vincent
van Gogh Foundation)

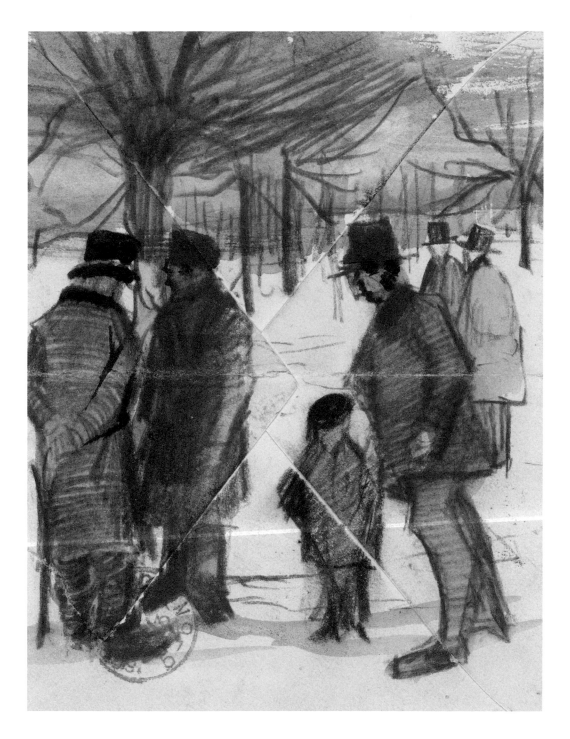

23. *Avenue of Poplars in Autumn* October 1884
Oil paint on canvas, on panel
99 × 65.7
Van Gogh Museum, Amsterdam (Vincent van Gogh Foundation)

24. *Autumn Landscape, Nuenen* October 1885
Oil paint on canvas
64.5 × 86.5
The Syndics of the Fitzwilliam Museum, University of Cambridge

25. *Head of a Peasant
Woman in a White Bonnet*
1885
Oil paint on canvas
47 × 35
The Norton Simon
Foundation, California

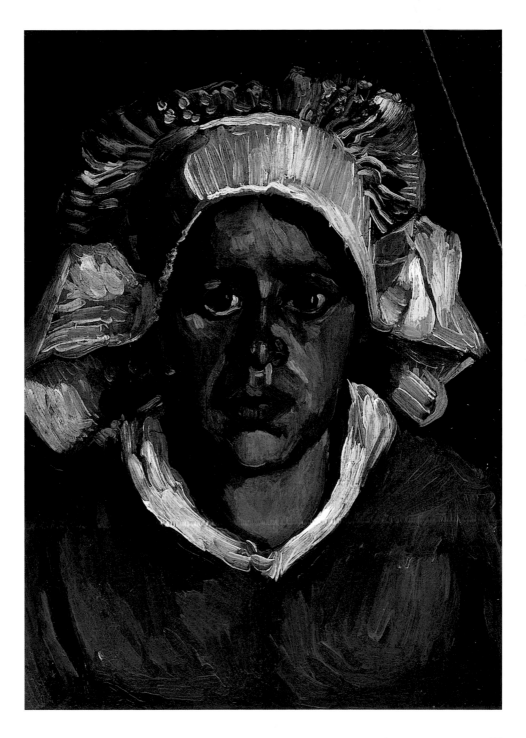

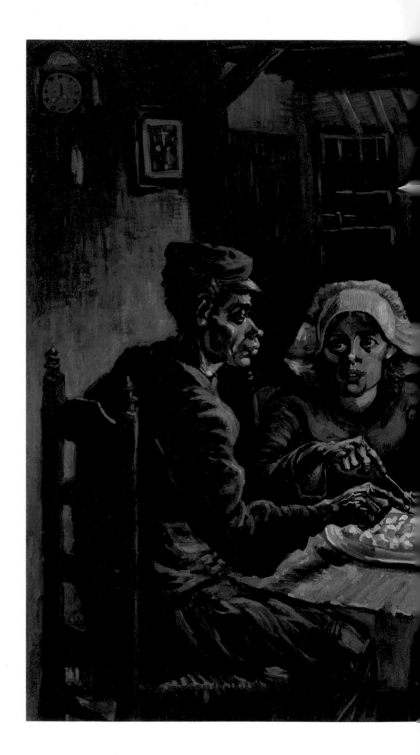

26. *The Potato Eaters*
April–May 1885
Oil paint on canvas
82 × 114
Van Gogh Museum,
Amsterdam (Vincent van
Gogh Foundation)

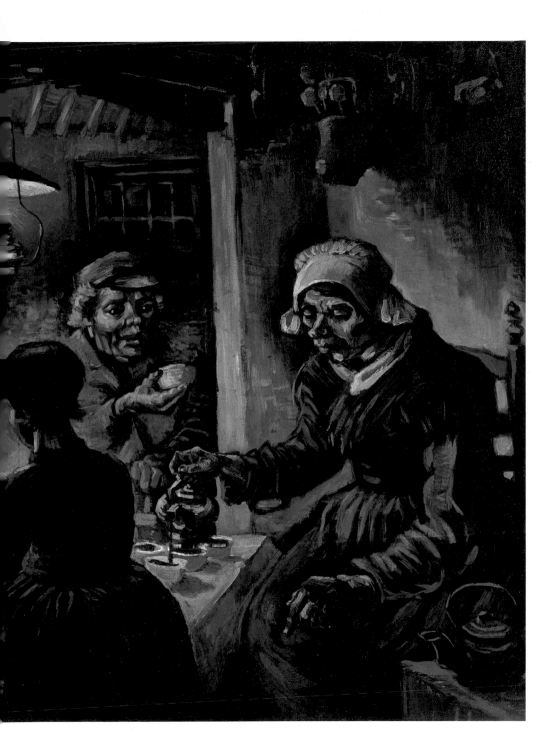

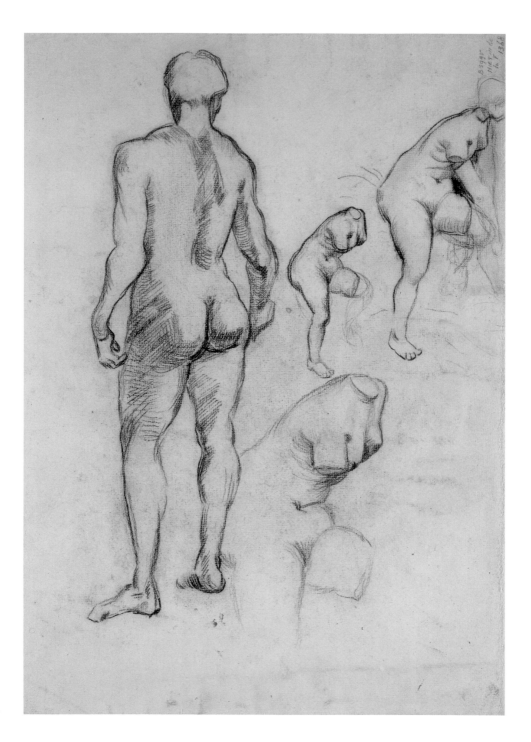

27. *Idol and Sketches of Venus* 1885
Chalk on paper
47.3 × 35.2
Van Gogh Museum, Amsterdam (Vincent van Gogh Foundation)

28. *Shoes* September–November 1886
Oil paint on canvas
38.1 × 45.3
Van Gogh Museum, Amsterdam (Vincent van Gogh Foundation)

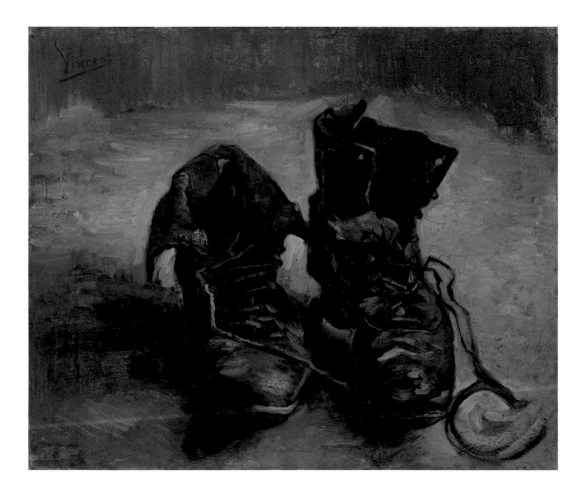

29. *View of Paris* 1886
Oil paint on canvas
53.9 × 72.8
Van Gogh Museum,
Amsterdam (Vincent van
Gogh Foundation)

30. *Portrait of Alexander
Reid* c.1887
Oil paint on pasteboard
42 × 34
Kelvingrove Art Gallery
and Museum, Glasgow

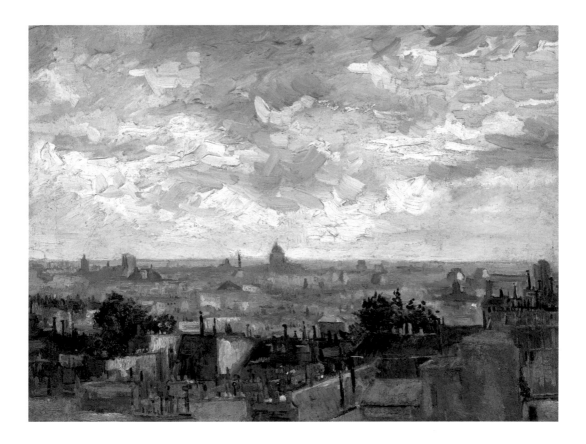

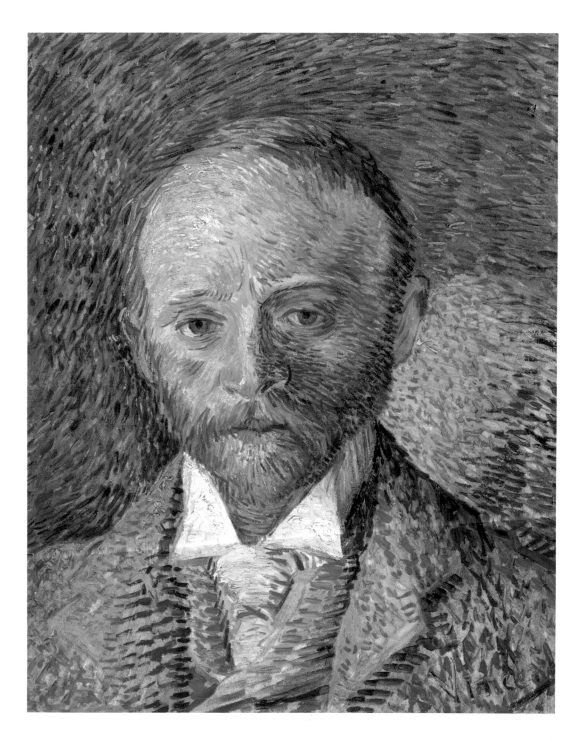

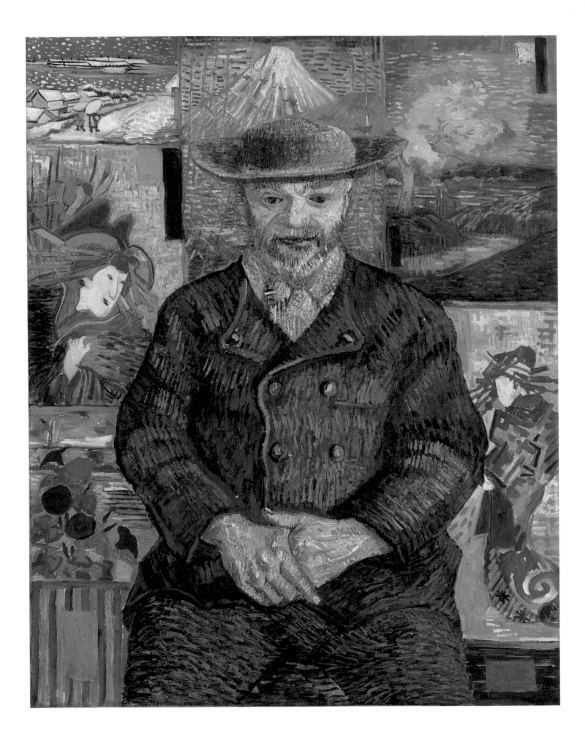

31. *Père Tanguy* 1887
Oil paint on canvas
92 × 75
Musée Rodin, Paris

32. *Sunflowers* 1887
Oil paint on canvas
43.2 × 61
The Metropolitan Museum
of Art, New York

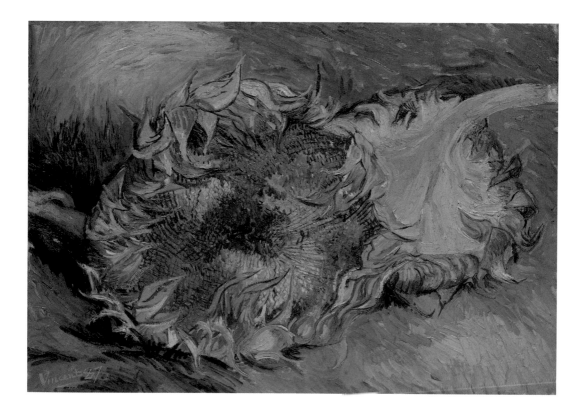

33. *Wheatfield with a Partridge* June–July 1887
Oil paint on canvas
53.7 × 65.2
Van Gogh Museum, Amsterdam (Vincent van Gogh Foundation)

34. *Self-Portrait with Grey Felt Hat* September–October 1887
Oil paint on canvas
44.5 × 37.2
Van Gogh Museum, Amsterdam (Vincent van Gogh Foundation)

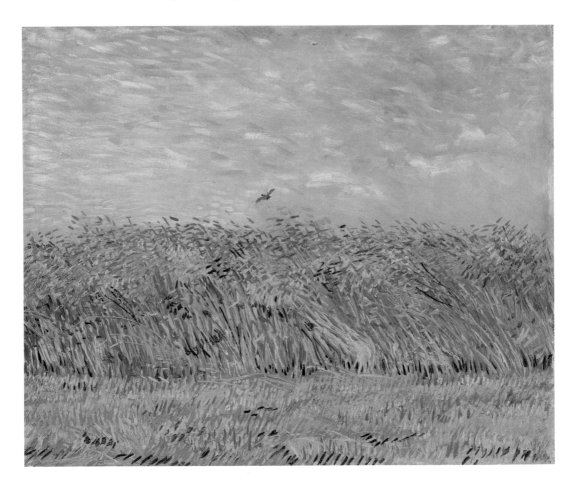

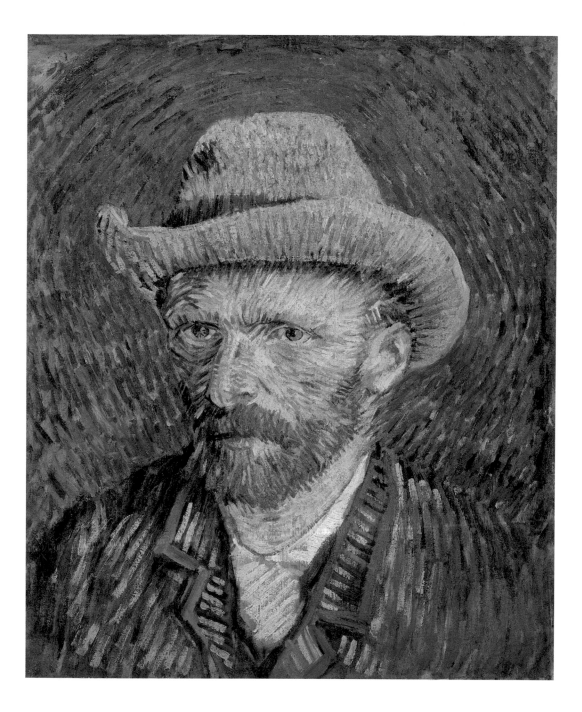

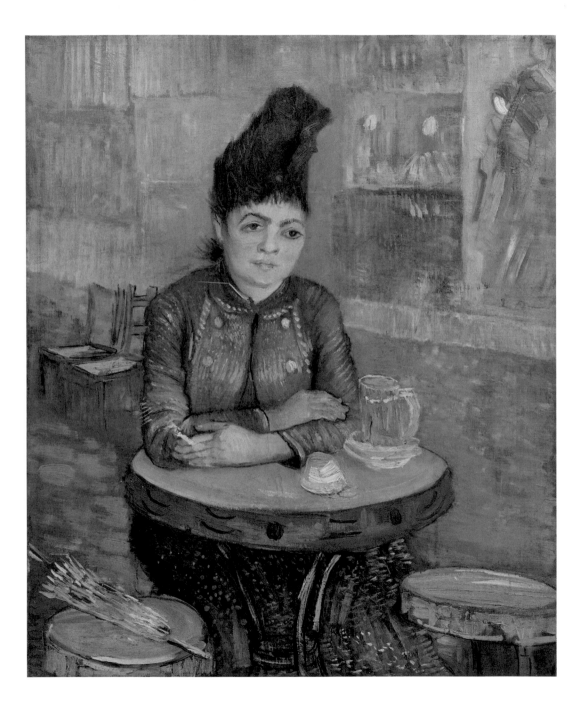

35. *In the Café: Agostina Segatori in Le Tambourin*
January–March 1887
Oil paint on canvas
55.5 × 47
Van Gogh Museum, Amsterdam (Vincent van Gogh Foundation)

36. *Bridge at Arles (Pont de Langlois)* mid-March 1888
Oil paint on canvas
49.5 × 64.5
Kröller-Müller Museum, Otterlo

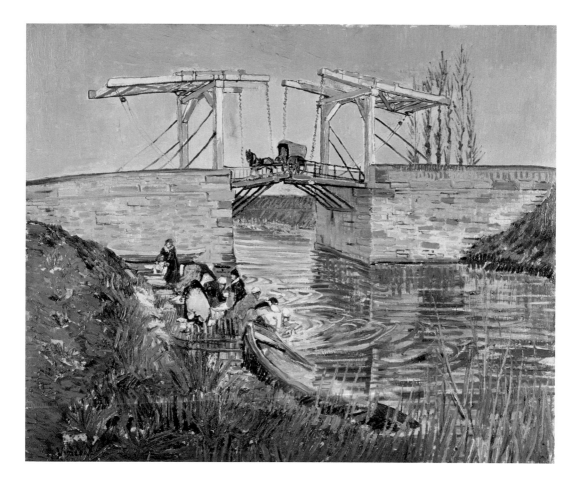

37. *The Bedroom*
1888
Oil paint on canvas
73.6 × 92.3
The Art Institute
of Chicago
Helen Birch Bartlett
Memorial Collection

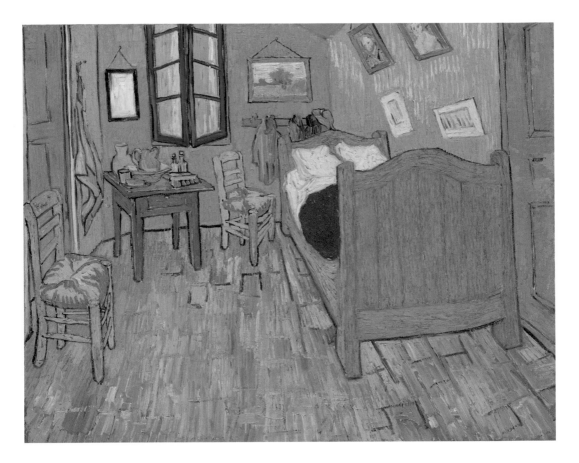

38. *The Sower*
November 1888
Oil paint on canvas
32.5 × 40.3
Van Gogh Museum,
Amsterdam (Vincent van
Gogh Foundation)

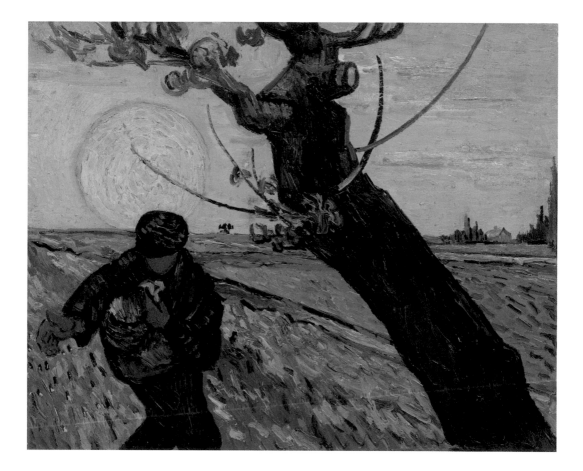

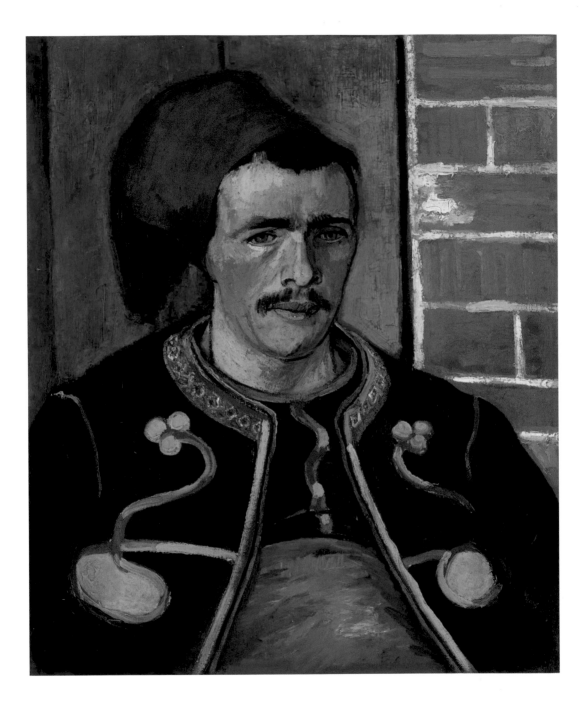

50

39. *The Zouave* June 1888
Oil paint on canvas
65.8 × 55.7
Van Gogh Museum,
Amsterdam (Vincent van
Gogh Foundation)

40. *The Night Café*
September 1888
Oil paint on canvas
72.4 × 92.1
Yale University Art Gallery

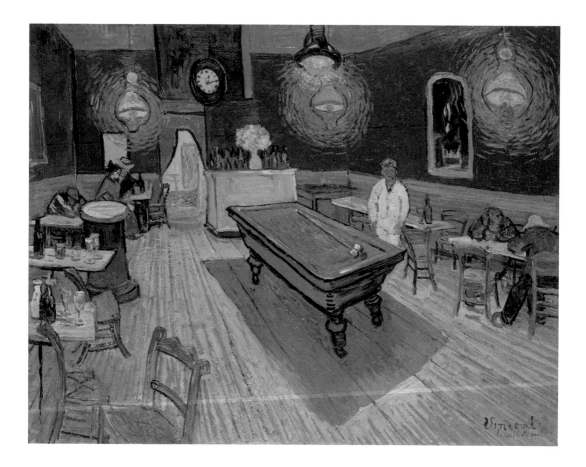

41. *Portrait of the Artist's Mother* October 1888
Oil paint on canvas
40.6 × 32.4
Norton Simon Museum, California

42. *Sunflowers* 1888
Oil paint on canvas
92.1 × 73
The National Gallery, London

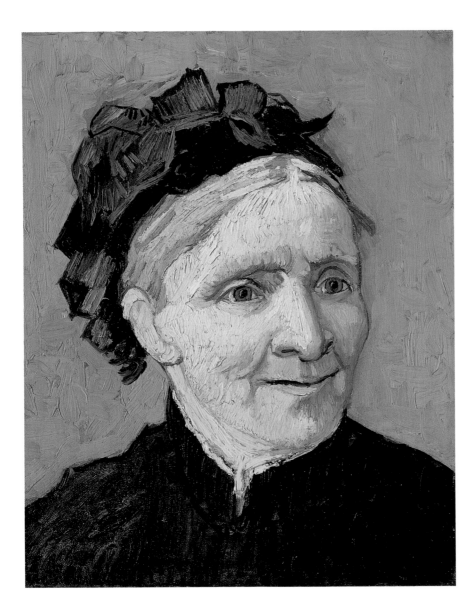

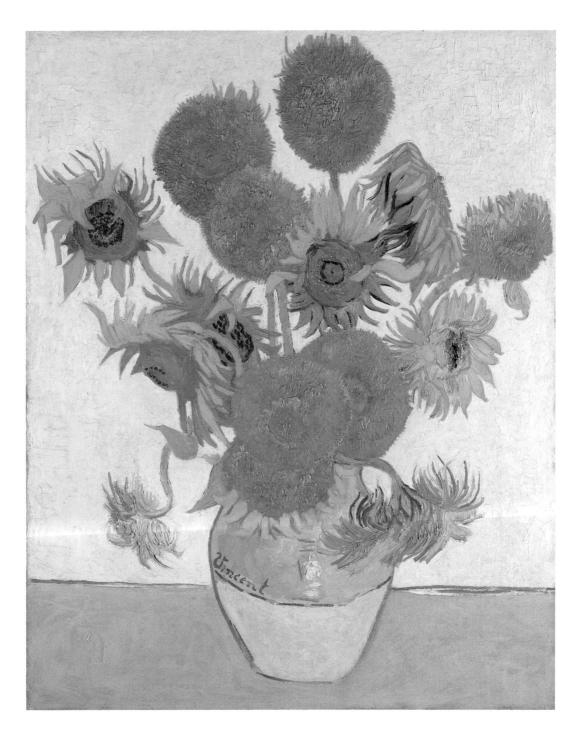

43. *Van Gogh's Chair*
December 1888
Oil paint on canvas
91.8 × 73
The National Gallery,
London

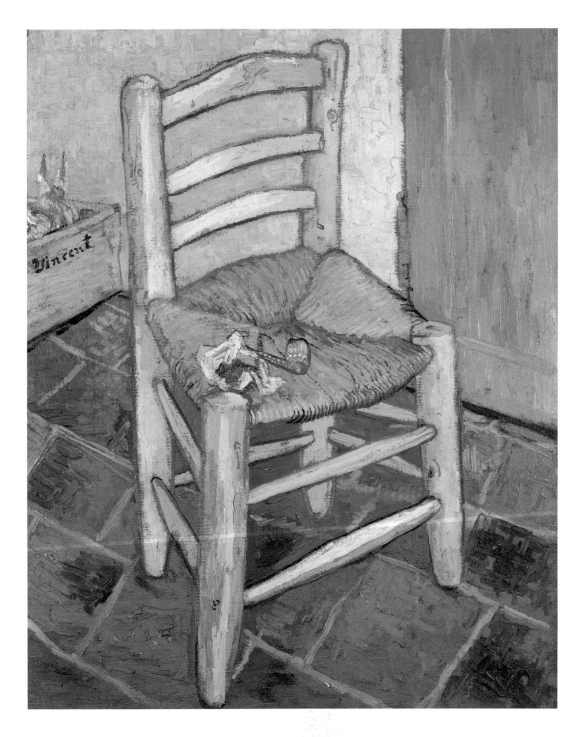

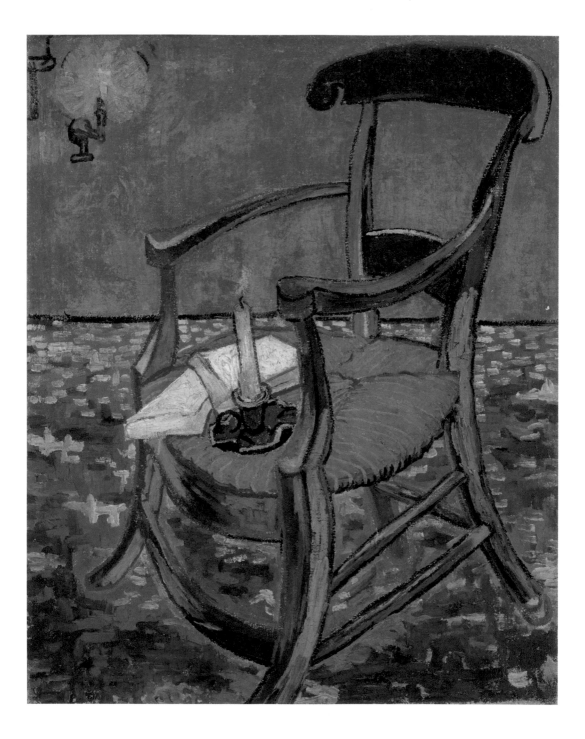

44. *Gauguin's Chair*
November 1888
Oil paint on canvas
90.5 × 72.7
Van Gogh Museum,
Amsterdam (Vincent van
Gogh Foundation)

45. *Seascape near les
Saintes-Maries-de-la-Mer*
June 1888
Oil paint on canvas
50.5 × 64.3
Van Gogh Museum,
Amsterdam (Vincent van
Gogh Foundation)

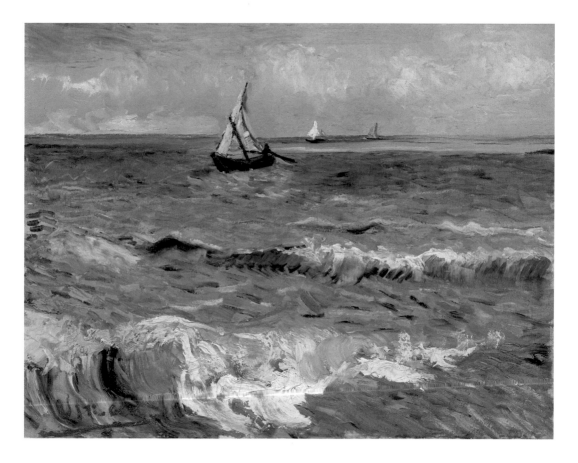

46. *Trunk of an Old Yew
Tree* October 1888
Oil paint on canvas
91 × 71
Private collection

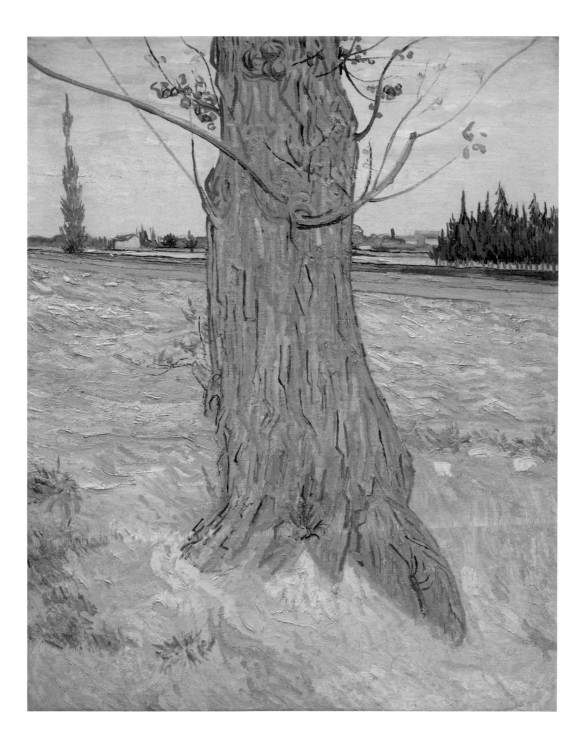

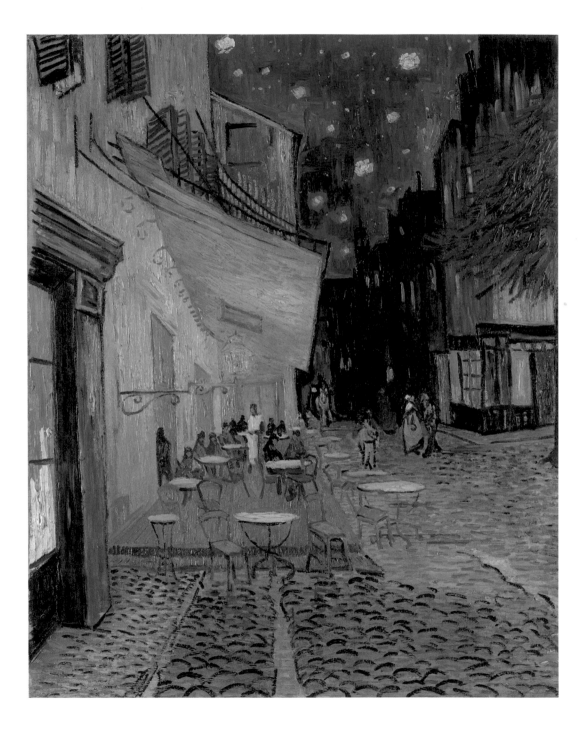

47. *Café Terrace at Night
(Place du Forum)* 1888
Oil paint on canvas
80.7 × 65.3
Kröller-Müller Museum,
Otterlo

48. *A Wheatfield,
with Cypresses* 1889
Oil paint on canvas
72.1 × 90.9
The National Gallery,
London

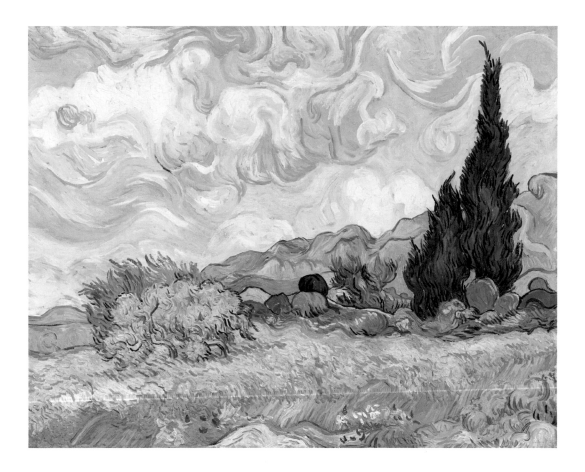

49. *Portrait of Joseph Roulin* April 1889
Oil paint on canvas
64.4 × 55.2
Museum of Modern Art, New York

50. *Augustine Roulin (La Berceuse)* March 1889
Oil paint on canvas
65 × 54
Stedelijk Museum, Amsterdam

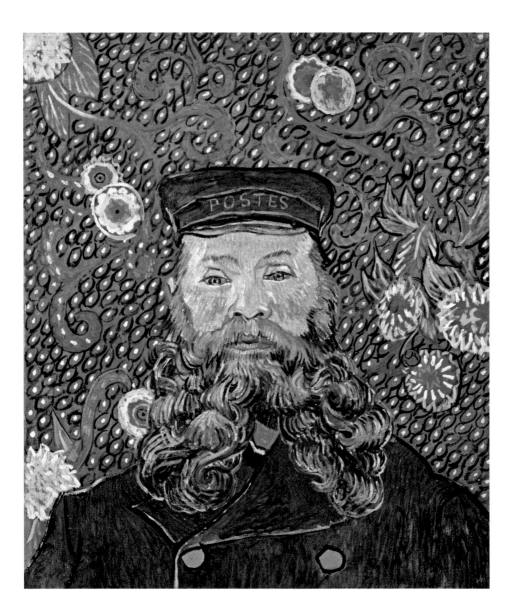

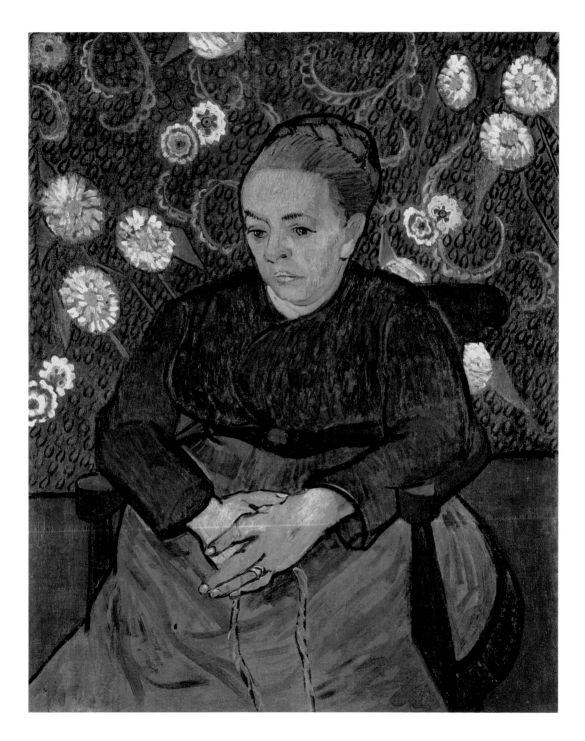

51. *The Starry Night* 1889
Oil paint on canvas
73.7 × 92.1
Carlsberg Glyptotek,
Denmark

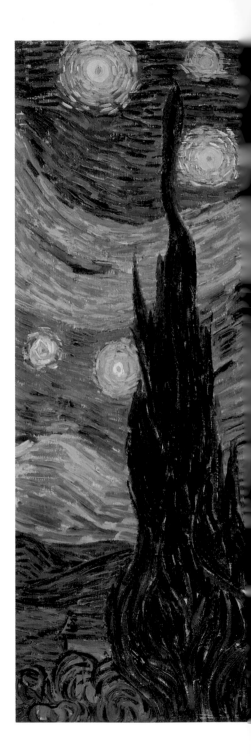

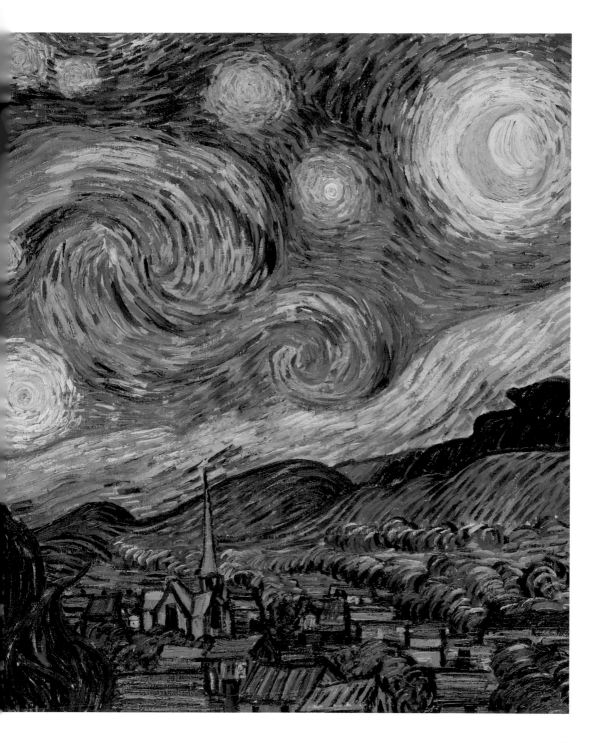

52. *Irises* 1889
Oil paint on canvas
74.3 × 94.3
The J. Paul Getty Museum,
Los Angeles

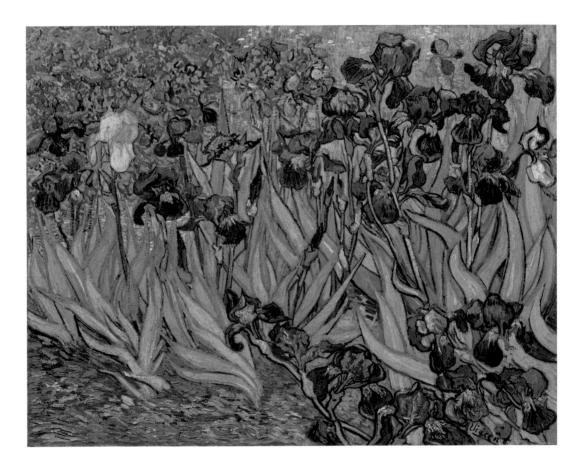

53. *Landscape with Olive Trees* 1889
Oil paint on canvas
72.6 × 91.4
Museum of Modern Art,
New York

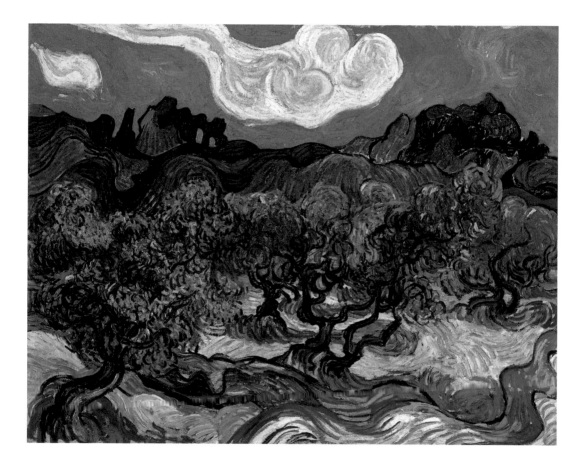

54. *Self-Portrait with
Bandaged Ear and Pipe*
January 1889
Oil paint on canvas
60.5 × 50
Private collection

55. *Self-Portrait* 1889
Oil paint on canvas
65 × 54.5
Musée d'Orsay, Paris

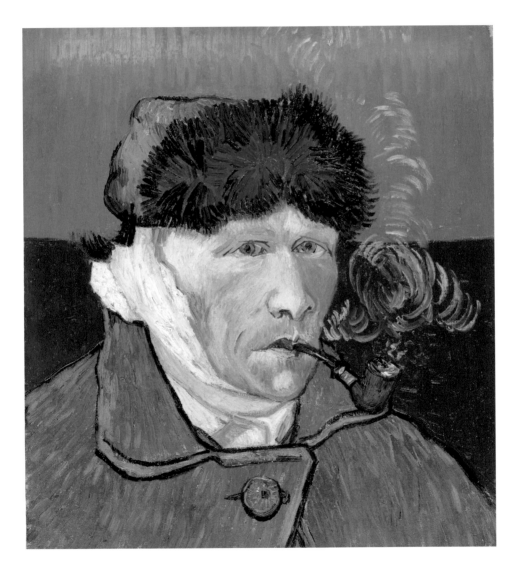

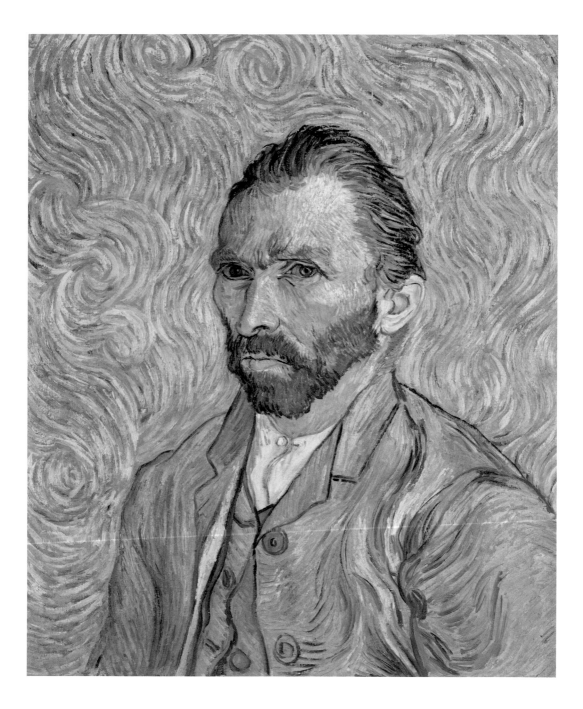

56. *The Prison Coutyard*
February 1890
Oil paint on canvas
80 × 64
The Pushkin State
Museum of Fine Arts,
Moscow

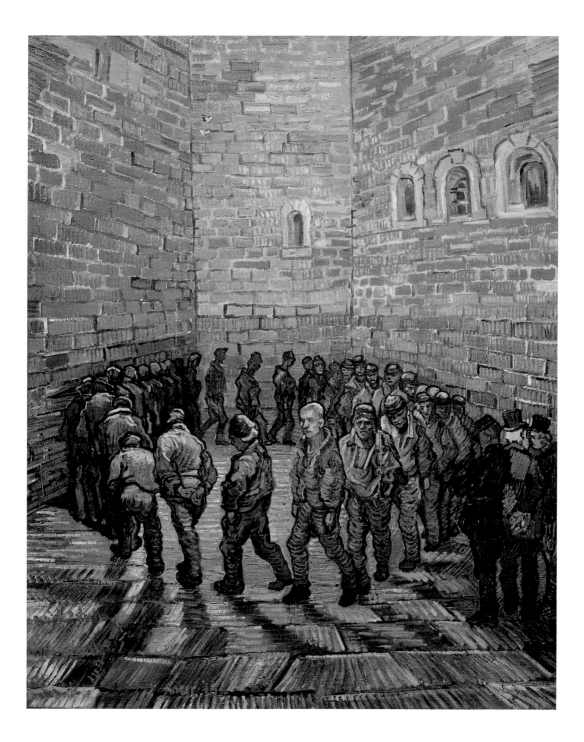

71

57. *The Arlésienne*
January–February 1890
Oil paint on canvas
64 × 54
Museu de Arte de São
Paulo Assis Chateaubriand
(MASP) -São Paulo, Brazil

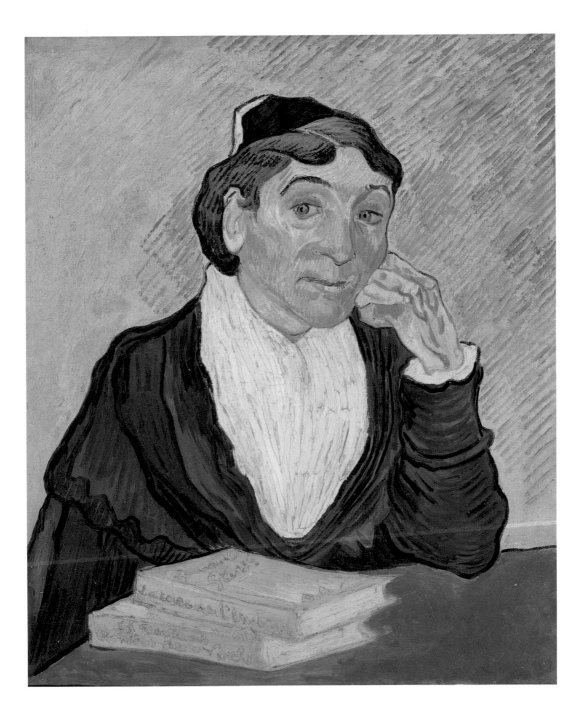

73

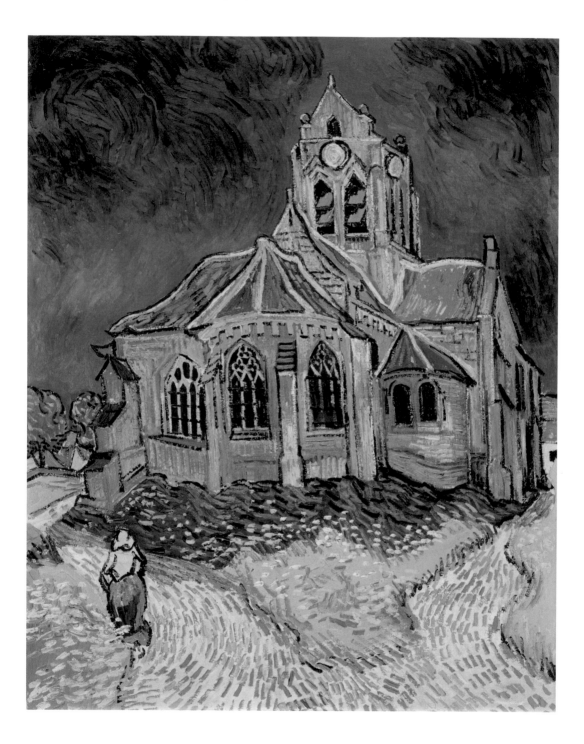

58. *The Church in Auvers-
sur-Oise* 1890
Oil paint on canvas
93 × 74.5
Musée d'Orsay, Paris

59. *Dr Paul Gachet* 1890
Oil paint on canvas
68 × 57
Musée d'Orsay, Paris

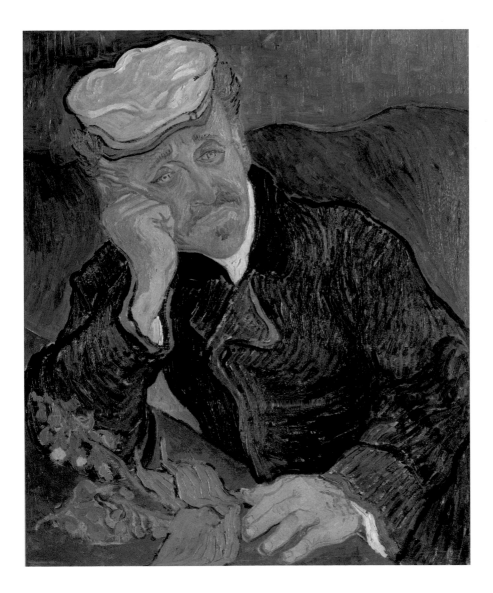

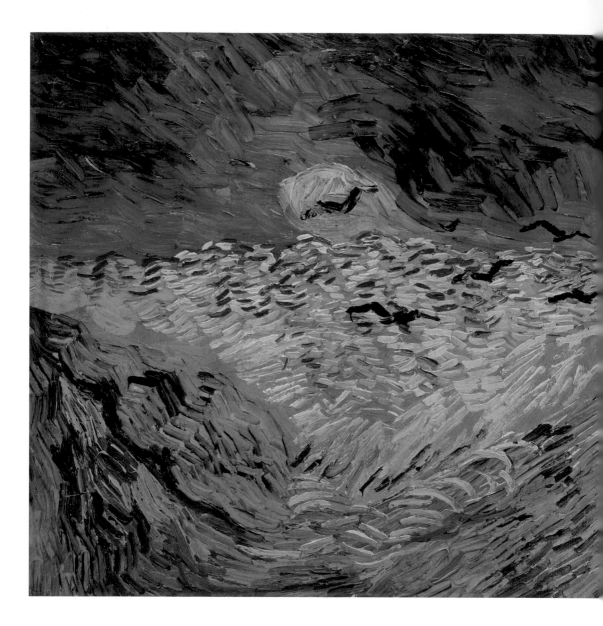

60. *Wheatfield with Crows*
1890
Oil paint on canvas
50.5 × 103
Van Gogh Museum,
Amsterdam (Vincent van
Gogh Foundation)

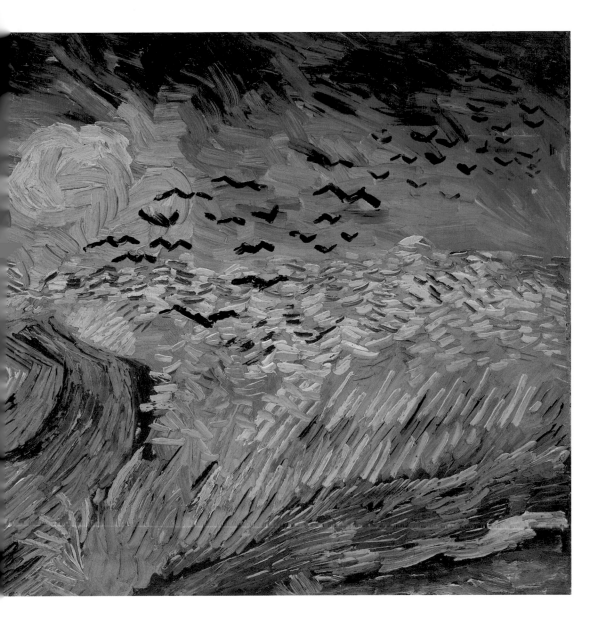

Notes

1 Jo van Gogh-Bonger, *A Memoir of Vincent van Gogh*, London 2015, p.33.

2 Carol Jacobi, 'Black and White' in *Van Gogh and Britain*, London 2019, p.8.

3 A.S. Hartrick, *A Painter's Pilgrimage Through Fifty Years* Cambridge, 1939, p.40.

4 Jo van Gogh-Bonger, *A Memoir of Vincent van Gogh*, p.52.

5 Letter 32 to Theo van Gogh, Paris, 24 July 1875.

6 Mr D. Braat recounts times at his father's bookstore, Blussé & Van Braam when Vincent worked there in 'Vincent van Gogh as Bookseller's Clerk' in *The Complete Letters of Vincent Van Gogh*, vol.1, London 1958, p.112.

7 Letter 155 to Theo van Gogh, 22–24 June 1880.

8 Ibid.

9 Letter 224 to Theo van Gogh, The Hague, 7 May 1882.

10 Letter 155 to Theo van Gogh, 22–24 June 1880.

11 Gogh-Bonger 2015, p.33.

12 Ann Dumas, 'Van Gogh in Paris' in *Van Gogh and Paris*, London 2013, p.18.

13 François Gauzi, *Lautrec et son temps*, Paris, 1954, p.31.

14 Dumas 2013, p.18

15 Martin Bailey, *Studio of the South: Van Gogh*, London 2016, p.15.

16 Ibid., p.21.

17 Letter 677 to Theo van Gogh, Arles 9. September 1880

18 Letter 666 to Theo van Gogh, Arles, 21 or 22 August 1888.

19 Paul Gauguin, *Avant et après*, Paris 1923, p.20

20 Bailey 2016, p.137.

21 Theo van Gogh to Jo Bonger 3–4 January 1889. See Leo Jnsen and Jan Roberts (eds.), *Brief Happiness: The Correspondence of Theo van Gogh and Jo Bonger*, Amsterdam 1999, p.81.

22 Gauguin 1923, p.20

23 *Van Gogh à Arles: Dessins 1888–89*, Arles 2003, pp.60–1.

24 Martin Bailey, *Starry Night: Van Gogh at the Asylum*, London 2018, p.38.

25 Letter 776 to Theo van Gogh. Saint-Rémy-de-Provence, on or about Thursday, 23 May 1889.

26 Letter 800 to Theo van Gogh, Saint-Remy, 5 and 6 September 1889.

27 Theo van Gogh to Anna and Wil, 15 April 1890.

28 Letter 898 to Theo and Jo, Auvers-sur-Oise, 10 July 1890.

29 Gauguin 1923, pp.29–32.

30 Theo died six months after Vincent, leaving his wife Jo with a new baby, an archive of letters and hundreds of paintings by her brother-in-law. Advised to consign the works to her attic, she instead set about translating and publishing his letters and organising exhibitions of his work that would ensure Vincent's passage out of obscurity.

31 Anna Gruetzner Robins, 'A toi, Van Gogh!: Van Gogh and British Artists' in *Van Gogh and Britain*, London 2019, p.104.

Index

Credits

First published 2019 by order of the Tate Trustees by Tate Publishing, a division of Tate Enterprises Ltd, Millbank, London SW1P 4RG
www.tate.org.uk/publishing

© Tate Enterprises Ltd 2019

A catalogue record for this book is available from the British Library
ISBN 978-1-84976-622-7

Distributed in the United States and Canada by ABRAMS, New York

Library of Congress Control Number applied for

Designed by Sarah Krebietke
Layout by Caroline Johnston
Colour reproduction by DL Imaging Ltd, London
Printed by Graphicom SPA, Italy

Front cover: Vincent van Gogh, *Agustine Roulin (La berceuse)* 1889 (see fig.50)
Frontispiece: Vincent van Gogh, *Sunflowers in a Vase* 1888 (see fig.42)

Measurements of artworks are given in centimetres, height before width.

References are to figure numbers.

Copyright

© The Estate of Francis Bacon. All rights reserved. DACS 2019 18

The J. Paul Getty Museum, Los Angeles 52

Collection Museu de Arte de São Paulo Assis Chateaubriand (MASP) - São Paulo, Brazil, MASP.00114 Gift, Evaristo Fernandes, Alfredo Ferreira, Walther Moreira Salles, Fúlvio Morganti, Ricardo Jafet, Carlos Rochas Faria, J. Silvério de Souza Guise, Assis Chateaubriand, Angelina Boeris Audrá, Louis La Saigne, Rui de Almeida, Henryk Spitzman Jordan, Mário Audra, Centro do Comércio do Café do Rio de Janeiro, a Spaniard, Moinho Fluminense S.A., Moinho Inglês S.A., Companhia América Fabril S.A., 1952 57

The New Art Gallery Walsall, Garman Ryan Collection 11

Photography

The Armand Hammer Collection, Gift of the Armand Hammer Foundation. Hammer Museum, Los Angeles 15

© 2019. The Art Institute of Chicago / Art Resource, NY/ Scala, Florence

© Ashmolean Museum, University of Oxford 9

© Christie's 2016 / Bridgeman Images 3

© The National Gallery, London 5

Collection Kröller-Müller Museum, Otterlo, the Netherlands 16

Courtesy The New Art Gallery Walsall 6

© The Fitzwilliam Museum, Cambridge 24

Digital image courtesy of the Getty's Open Content Program 52

© CSG CIC Glasgow Museums and Libraries Collections 30

The Metropolitan Museum of Art, New York 32

Collection Museu de Arte de São Paulo Assis Chateaubriand (MASP) - São Paulo, Brazil, MASP.00114. Photo by João Musa 57

© 2019. Digital image, The Museum of Modern Art, New York/Scala, Florence 49, 51, 53

Musee d'Orsay, Paris 55, 58, 59

General Research Division, The New York Public Library 19

© Musée Rodin – photo Jean de Calan 31

© The National Gallery, London. Bought, Courtauld Fund, 1924 42, 43

© The National Gallery, London. Bought, Courtauld Fund, 1923 48

© The National Gallery, London 5, 42

The Norton Simon Foundation 25, 41

Photo: © Tom Powel Imaging 2018 46

Photo © RMN-Grand Palais (musée d'Orsay) / Gérard Blot 55, 59

Photo © RMN-Grand Palais (musée d'Orsay) / Hervé Lewandowski 58

Private collection 13, 3, 54

Rijksmuseum Kroller-Muller, Otterlo, Netherlands / Bridgeman Images 47

Rijksmuseum Kroller-Muller, Otterlo, Netherlands / De Agostini Picture Library / Bridgeman Images 36

© 2019. Photo Scala, Florence 56

© 2019. Photo Scala, Florence/bpk, Bildagentur fuer Kunst, Kultur und Geschichte, Berlin 11

Tate, London 2019 13, 17, 18, 21

Van Gogh Museum, Amsterdam (Vincent van Gogh Foundation) 1, 2, 4, 7, 8, 10, 12, 14, 20, 22, 23, 26, 27, 28, 29, 32, 33, 34, 35, 37, 38, 39, 44, 45, 60

Yale University Art Gallery 40

Yooniq images 19